THREE PALACE
BISHOPS OF WIN

WOLVESEY
(Old Bishop's Palace)
HAMPSHIRE

BISHOP'S WALTHAM PALACE

HAMPSHIRE

FARNHAM CASTLE KEEP

SURREY

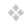

John Wareham

❖ CONTENTS ❖

Published by English Heritage
23 Savile Row, London W1S 2ET
www.english-heritage.org.uk
© English Heritage 2000
First published by English Heritage 2000

Photographs, unless otherwise stated, were taken by English Heritage Photographic Unit and
remain the copyright of English Heritage (Photographic Library; tel: 020 7973 3338)

Edited by Lorimer Poultney
Design by Derek Lee
Artwork by Hardlines
Printed in England by Sterling Press, Wellingborough
ISBN 1 85074 721 0
LP C80 1/01 FA6694

INTRODUCTION

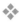

The Church in medieval England and Wales was divided into 21 dioceses, or areas of administration, each under the control of a bishop. Each diocese had extensive estates, or manors, some of which were given to the bishop for him to derive an income and support his household, the remainder providing an income for the diocese's clergy. At the most important of the bishops' manors were houses where they could lodge during their travels around their diocese.

For the bishops of Winchester, the palace in the cathedral city was at Wolvesey. In addition, there were castles or houses at Farnham and

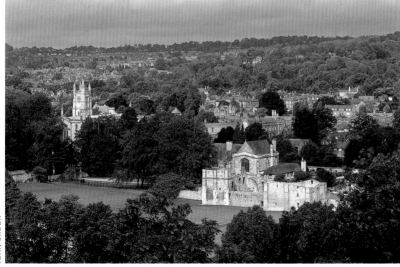

Wolvesey, seen from St Giles Hill, with Wykeham's Winchester College behind to the left.

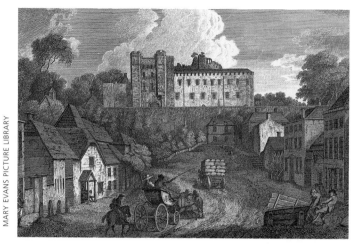

Eighteenth-century view of Farnham Castle and Castle Street

household, and the place where the bishop entertained and held court. The buildings also served a variety of functions: as showpieces for wealth and power, administrative centres for their vast estates, places of refuge in times of trouble, places for rest and leisure, and accommodation for officials of the household and guests.

The form of the buildings mirrored the buildings of great secular lords of the time, centred around a hall, kitchen, great chamber and chapel. As time progressed, and greater privacy was expected, further rooms were added to give the bishops more private accommodation, while more self-contained accommodation was also provided for officials and guests. Other buildings provided service functions, such as the brewhouse and bakehouse, stables and barns. The palaces were the hubs of the bishop's estates, and fufilled roles as agricultural centres. There were also buildings with more specialised purposes, such as the collection of wool at Wolvesey, or the bishop's prison (the 'clink') in London.

Esher in Surrey, Taunton in Somerset, Bishop's Waltham and Merdon in Hampshire, Downton in Wiltshire, and a London house on the south bank of the River Thames at Southwark. There were also manor houses at several other estates that the bishops used, including East Meon, Highclere and Marwell in Hampshire and Witney in Oxfordshire.

Palaces

In medieval terms, the word 'palace' was generally used for the bishop's house nearest the bishop's cathedral, as this was the formal centre of administration for his diocese, as well as a residence.

The functions of the other houses varied as different bishops chose which one they preferred. The bishop's house was at the same time both private and public: the home of the bishop and his extensive

Castles

Medieval bishops were not unusual in having castles. Many bishops in the eleventh and early twelfth centuries had built castles on their estates, just as barons had, in order to defend their lands or to protect towns that they had founded to encourage trade.

While the castles had become less important as military strongholds by the later Middle Ages, the threat of lawlessness ensured that many of the bishops' residences were fortified in some way, with the major dioceses maintaining at least one castle. The defences of Farnham Castle were kept ready against attack well into the sixteenth century.

The involvement of bishops in the church courts and as large landowners meant that they were often the focus of discontent from aggrieved parties or from townspeople or peasants who felt oppressed by the taxes that they had to pay to the Church, and who sometimes resorted to violence. The role of bishops as ministers of the king could also make them unpopular: Archbishop Simon of Sudbury was murdered during the Peasants' Revolt of 1381. Strong walls, moats and towers are therefore all features of bishops' residences of this period, just as cathedral closes themselves were often 'crenellated' with walls and gatehouses to protect the clergy.

WHAT DID BISHOPS DO?

Medieval bishops were primarily administrators, responsible for overseeing the clergy and most of the monasteries in their diocese, imposing discipline and correction and carrying out orders from royal

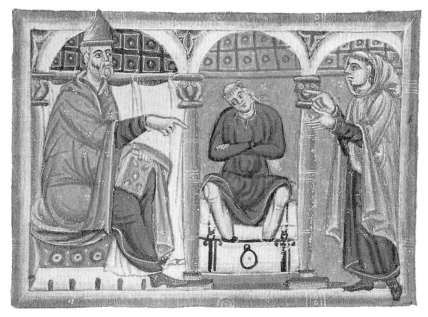

A bishop lecturing a monk sitting in the stocks. Bishops were responsible for discipline among the clergy

or church superiors. They were constantly on the move, travelling between their estates and houses, supervising the clergy in their diocese, but also checking on the management of their estates. In addition, many bishops also had to attend the royal court as they held key administrative posts: the medieval bishops of Winchester included four treasurers and ten lord chancellors among their number. Bishops were therefore important political figures, both in the Church and in their local region, and often in national politics as well. The cathedral was the territory of the dean and chapter (or prior and convent if it were a community of canons) so contrary to what we might expect today most medieval bishops spent little time in their cathedrals.

The bishop had a large household of officials and servants to help him carry out his duties. On the clerical side these included archdeacons and rural deans who supervised the administration of parishes, the vicar-general who was the bishop's deputy in spiritual affairs, the chancellor who supervised the church courts, and the registrar or treasurer who looked after the accounts and records.

In addition, a great lord like the bishop of Winchester would have attracted numerous important lay people to serve in his household as stewards of his estates and manors, constables of his castles, and other offices. A host of other servants, usually male, helped make the other functions of the household run smoothly.

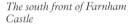

The south front of Farnham Castle

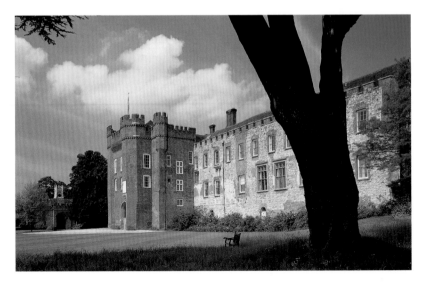

HISTORY OF THE BISHOPS AND THEIR HOUSES

In medieval times, the diocese of Winchester was the richest in England, and one of the richest in Western Europe. Until 1927, when it was divided into three, it stretched from Surrey to the Isle of Wight. It derived its wealth from its extensive estates, granted when the bishops of Winchester were closely identified with the monarchs of the Kingdom of Wessex, and later Anglo-Saxon kings of England, whose capital was at Winchester.

EARLY BISHOPS

The early Anglo-Saxon bishops lived as part of the community of the cathedral church and did not need separate accommodation, but church reform in the mid-tenth century meant that it was no longer practical for a bishop, who had many duties in the outside world, to be part of a monastic community. It was therefore Aethelwold (bishop 963–84) who enclosed the area and built the first

bishop's residence at Wolvesey. There may have been residences at other of the bishops' manors before the Norman Conquest in 1066, but it was the Normans who clearly established the pattern of houses for the see.

THE NORMANS

William Giffard, the second Norman bishop, had been chancellor under William Rufus and Henry I before his appointment to Winchester in 1100. At Wolvesey he built the west hall, an impressive stone building that reflected the importance and wealth of such a influential person.

It was Henry of Blois (bishop 1129–71) who played the most significant role in establishing the palaces and houses of the bishops of Winchester that served the bishops during the Middle Ages. The brother of King Stephen, he played an important role in the politics of the period and his building projects reflected the extent of his power. He

❖ HENRY OF BLOIS ❖

Henry was the son of the Count of Blois and a grandson of William the Conqueror. His contemporaries viewed him as a man of exceptional ability and taste, and a great patron of arts and letters, as well as an avid builder. His biographer, Gerald of Wales, wrote that he built 'wonderful buildings, sumptuous palaces, huge ponds, complex aqueducts and hidden underground passages in various places'.

Henry had begun his career as a monk in the great Burgundian abbey of Cluny, before becoming abbot of Glastonbury and then holding this office alongside his bishopric when appointed to Winchester in 1129. The vast wealth from these two posts gave him the means to pursue his ambitions.

When his brother Stephen became king in 1135, Henry became the king's chief adviser. Henry's pivotal position in the kingdom meant he soon became deeply embroiled in the power struggle that developed between Stephen and Matilda, Henry I's sole surviving legitimate child. In 1141, with Stephen captured by Matilda's forces at Lincoln, Henry changed sides and as papal legate prepared to consecrate her as queen. Alienated by Matilda's attitude, however, he changed sides again, fortifying his castles and going on the offensive, during which parts of the city of Winchester were burnt by Henry's forces. Effectively in exile after Stephen's death in 1154, he returned in 1158 to act as an 'elder statesman' of the English Church until his death in 1171.

An enamel plaque, showing Henry of Blois. Part of the inscription in Latin modestly describes him as 'Henry, whose fame commends him to men, whose character commends him to heaven, a man equal in mind to the Muses and in eloquence higher than Marcus [Cicero].'

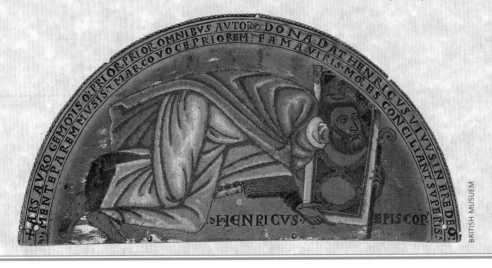

BRITISH MUSUEM

used his wealth not only to create an impressive palace for himself at Wolvesey, but to build castles and fortified houses at several other sites to protect the bishopric's estates during the troubled years of Stephen's reign. The Winchester Annals of 1138 record that Henry had built a 'house like a palace' (Wolvesey) at Winchester, as well as a castle or 'strong tower', and castles at Taunton, Downton, Farnham, Bishop's Waltham and Merdon.

After the accession of Henry II in 1154, orders were given for Bishop Henry's 'unlicensed' castles to be destroyed. Some were pulled down, such as at Farnham, but after Henry's return from exile in 1158 the bishop seems to have concentrated on rebuilding his main palaces, making them grander and more impressive than before. Certainly the sites of his castles remained important houses for later bishops.

Both Wolvesey and Farnham were captured by French troops in 1216 supporting the French Dauphin Louis in his claim to the English throne and recaptured by royal troops a year later, but there seems to have been no sustained siege at either site or much damage caused.

Henry's building work may have been carried on by his successor, Richard of Ilchester, and then by Peter des Roches (bishop 1205–38) who played a significant role in the minority of Henry III. In particular,

Peter des Roches was probably responsible for remodelling Henry's east hall at Wolvesey and for rebuilding the hall range at Winchester Palace in London to create impressive halls equal to his contemporary hall of the royal castle at Winchester which survives today.

LATER MEDIEVAL PERIOD

During the late fourteenth and fifteenth centuries the see of Winchester was fortunate in having only three bishops, all men of ability, power, wealth and influence, who held office for long periods: William of Wykeham (1367–1404), Cardinal Henry Beaufort (1405–47) and William Waynflete (1447–86). All three were also highly influential in affairs of state under Edward III, Richard II, Henry VI, V and VI.

As holders of high office, they used the wealth derived from the bishopric to modernise the palaces to create up-to-date accommodation suitable for great lords of their rank and their rapidly expanding households. Wykeham was responsible for the remodelling of Bishop's Waltham and work on Wolvesey, Beaufort built the lodging range at Waltham and new chapels at Wolvesey and Waltham, while Waynflete built the entrance tower at Farnham Castle as well as a large palace in Esher, of which only the brick gatehouse

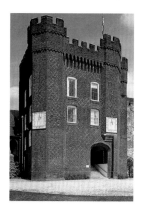

Waynflete's brick tower at Farnham Castle

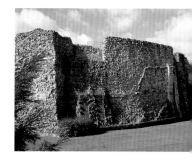

The wall of the shell keep of Farnham Castle

❖ WILLIAM OF WYKEHAM ❖

William of Wykeham's career typifies the rise of the royal servant from relatively humble origins to the highest offices of state. Ambitious, capable and efficient, as clerk of the king's works at Windsor he had been responsible for overseeing Edward III's lavish rebuilding of Windsor Castle.

This familiarity with building is reflected in the work he carried out at Winchester Cathedral and on the see's houses, especially Bishop's Waltham. He often supervised the work personally, and used skilled craftsmen, such as the great architects William Wyland and Henry Yevele and

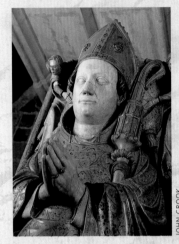

William of Wykeham: detail of his tomb effigy in Winchester Cathedral

JOHN CROOK

the master carpenter Hugh Herland.

As well as being appointed bishop of Winchester in 1367, he held the important posts of keeper of the privy seal and lord chancellor. His accumulation of church benefices made him rich, but also contributed to a trial for corruption and temporarily being deprived of his possessions. He survived, however, and returned to favour under Richard II in 1377, remaining bishop until his death in 1404.

Wykeham is best remembered today for his two educational foundations: Winchester College and New College, Oxford, both designed to train clergy for the Church.

survives today. There was also extensive and on-going repair work to the older buildings, such as reroofing, laying floors and reglazing, and work to the other houses of the bishops.

The Reformation

Regular maintenance on the bishops' houses continued in the sixteenth century, with Bishops Langton (1493–1501) and Fox (1501–28) making extensive repairs and additions

to the fabric of the existing palaces, Langton in particular making alterations to Taunton Castle, for example.

Religious upheaval in the mid-sixteenth century was to have a major impact on the role of bishops. The assumption of the role of head of the church by the monarch, and the increasing use of lay ministers in preference to clerics, lessened the influence of the bishops in the affairs of state. The seizure of episcopal lands also reduced their incomes:

❖ CARDINAL HENRY BEAUFORT ❖

Henry Beaufort was born in 1377, the second son of John of Gaunt, Duke of Lancaster, by his then mistress Katherine Swynford. Legitimised with the rest of the Beaufort family by Richard II in 1397, he was Henry IV's half-brother. Vain and arrogant, Beaufort used his wealth to further his own ambitions and those of the Beaufort family during the minority of Henry VI, whom he crowned king in Paris in 1421, by lending vast sums of money to the Crown (usually at high rates of interest).

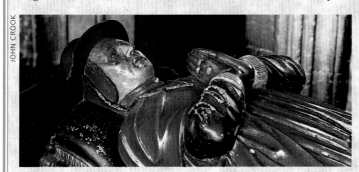

He was made a cardinal in 1426, but his allegiance to the Pope sometimes made him unpopular at home in England.

He made many alterations to the episcopal houses, but also refounded the Hospital of St Cross in Winchester, most of whose buildings date from his tenure as bishop.

The effigy of Henry Beaufort from his tomb in Winchester Cathedral, dressed in his cardinal's red robe and hat

❖ WILLIAM WAYNFLETE ❖

On Beaufort's death in 1447, his protégé Waynflete, then provost of Eton College, was appointed as bishop. A close friend and adviser of Henry VI, Waynflete served as lord chancellor between 1456 and 1460, but his political skills were soon engulfed by the civil strife that erupted between Lancastrian and Yorkist factions struggling for the throne. Although a supporter of the Lancastrians, he eventually accepted the Yorkist monarchy and largely retired to his diocese until his death in 1486. Like Wykeham, Waynflete also used his wealth and influence to support education, founding Magdalen College, Oxford, as well as schools, including his birthplace of Wainfleet, Lincolnshire.

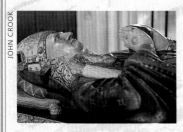

William Waynflete, from his tomb in Winchester Cathedral

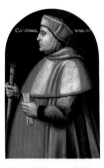

Cardinal Thomas Wolsey: 'the proudest prelate that ever breathed'. Wolsey coveted the see of Winchester but had to wait until the death of his former patron, Bishop Fox, in 1528

Stephen Gardiner, described by the Protestant John Foxe as 'wily Winchester' because of his political scheming

following the Dissolution of the Monasteries in the 1530s and the abolition of chantries in 1547, the Crown saw church lands as an easy source of much-needed income.

The bishop of Winchester at this time was Stephen Gardiner, who had succeeded his employer Cardinal Wolsey as bishop in 1531. During the 1540s, Gardiner was one of the leading traditionalists among the courtiers manoeuvring for influence in the court of the elderly Henry VIII, but fell from favour soon after the accession of Edward VI because of his opposition to religious changes. He spent much of Edward's reign imprisoned in the Tower of London, and in 1551 was deprived of his post.

The same year the Crown seized most of the lands of England's bishops. Reform went furthest in the diocese of Winchester under the Protestant John Ponet, who had replaced Gardiner, the bishop accepting a fixed salary in return for surrendering the majority of his estates. Only Wolvesey, Farnham and Southwark remained in the bishop's hands. In 1553 Gardiner was released and restored to the bishopric with the accession of the Catholic Queen Mary, marrying Mary and Philip II of Spain in Winchester Cathedral in 1554. This was the last real state occasion for the palaces, when Waltham and Farnham were used by the queen while waiting for Philip's arrival, and the wedding banquet was

held in Wolvesey itself. Waltham was restored to the ownership of the bishops in 1558.

Gardiner's successor, John White, refused to take the oath of supremacy to Elizabeth as head of the church and was sent to the Tower and deprived of the bishopric in 1559. He was replaced by the Protestant Robert Horne in 1561, but only after Elizabeth had enjoyed the income of the see for one and a half years.

Civil War

The reduced circumstances of the bishops in the Elizabethan Church led to inevitable neglect. In 1608 Bishop Bilson leased Farnham to King James I for the bishop's lifetime, as the king was interested in the hunting in the surrounding deer parks. The surveyor John Norden, employed by James I to report on the condition of Farnham, discovered broken fences, squatters in the park and dilapidated buildings.

The succeeding bishops – Lancelot Andrewes (bishop 1619–26) and Richard Neale (bishop 1628–32) – were leading supporters of High Church doctrines at a time when such beliefs were fostering divisions that were to lead to the Civil War. Under Andrewes Farnham returned to the bishop's control, as part of a general move among High Church clergymen to restore the status of the bishops.

The bishop at the time of the

outbreak of the Civil War in 1642 was Walter Curle, a firm supporter of the Crown, but he was unable to prevent Parliamentary supporters occupying Farnham Castle in October 1642. The following month, however, the castle was evacuated in the face of approaching Royalist forces. Critics of the Parliamentarian commander, George Wither, claimed his greatest contribution to the castle's defence was gathering the horses and carts for the evacuation!

On 1 December 1642 a Parliamentary army led by Sir William Waller counter-attacked, blowing up the main gate and forcing a surrender by the Royalist garrison. Orders were given for the castle to rendered indefensible, and part of the wall of the shell keep destroyed by gunpowder. The habitable part of the castle became Waller's headquarters for much of 1643 and 1644, but in January 1645 it was recaptured during a Royalist raid led by Lord Goring. Unable to garrison the castle effectively, the Royalists abandoned it after a day and it remained in Parliamentary hands for the rest of the war.

Bishop's Waltham was fortified as a strongpoint by Royalist forces, but in the aftermath of the Royalist defeat at the battle of Cheriton on 29 March 1644 the garrison led by Colonel Bennett was forced to surrender and major damage seems to have been done, rendering the palace uninhabitable. Local tradition holds that the

bishop escaped in a dung-cart under a layer of manure.

The city of Winchester itself changed hands several times during the Civil War, but Wolvesey seems to have lain empty and unused during this time. By 1645 the Royalists had reoccupied Winchester, and Bishop Curle himself was involved in defending the royal castle against attack by Cromwell. After the garrison's surrender, Curle was deprived of his post, property and income.

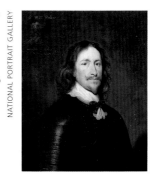

Sir William Waller, commander of Parliament's Western Association army during the Civil War

HISTORY OF THE PALACES AFTER THE CIVIL WAR

In 1647 Parliament abolished bishops in the Church of England and confiscated all episcopal property in order to sell it. Farnham Castle was sold to John Godwyn, MP for Haslemere, and Winchester Palace in Southwark was sold and divided up into tenements. Bishop's Waltham, even in its ruined state, was sold for nearly £8,000. At the Restoration of the monarchy in 1660, the bishops and their properties were restored and Bishop Brian Duppa began to repair Wolvesey. This work was continued by his successor George Morley, using materials from the semi-ruined Bishop's Waltham. Morley was also busy with repair work at Farnham. Over £10,000 was spent on Farnham between 1662 and 1684, compared with only £2,000 on

❖ GEORGE MORLEY ❖

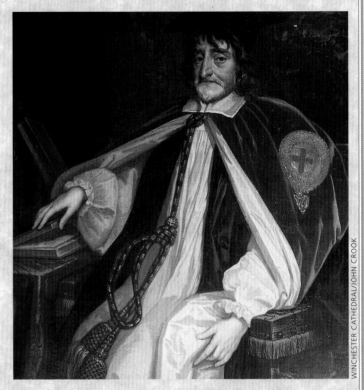

George Morley, in a copy of a portrait by Sir Peter Lely

WINCHESTER CATHEDRAL/JOHN CROOK

George Morley was born in 1597 and educated at Westminster and Christ Church, Oxford. Here he made many friends, in particular Edward Hyde, later Earl of Clarendon, whose patronage helped him until Clarendon's fall from favour in 1667.

Although a moderate churchman, Morley supported the royalist cause during the Civil War and in 1649 he left England to join the court of the exiled Charles II. On the Restoration in 1660, the bishops were re-established and Morley made bishop of Worcester. He was then translated to Winchester in 1662, Charles II declaring that although the bishopric was rich, Morley would never be the richer for it, such was his reputation for generosity. Morley's determination to restore the dignity of the bishop's office is reflected in the work he carried out on the episcopal houses, in particular Wolvesey and Farnham Castle. In addition, he bought a new house for the see in London, Winchester House in Chelsea. He died in 1684.

the new palace at Wolvesey (see below).

By the early 1680s, however, Morley had decided to abandon his attempts to refurbish Wolvesey and build a completely new palace on the site instead, perhaps prompted by Charles II's decision to build a royal

palace at Winchester. The medieval chapel was retained, but the moat was filled in and the rest of the palace stripped to provide materials to create a new palace in the Baroque style immediately south of the medieval palace. Morley left a legacy of £500 in his will to complete building work, but this was not taken up until Sir Jonathan Trelawny (bishop 1707–21) used it to build the east wing and converted the old outer court buildings into stables and coach house.

By the mid-eighteenth century the bishops preferred Farnham Castle as their main residence. Further work was done to update Farnham, particularly by Bishop Thomas (1761–81) to convert it into a Georgian residence. Wolvesey, by contrast, was neglected and in 1785 Bishop Brownlow North demolished all of the Baroque palace apart from the west wing.

Bishop's Waltham Palace, although returned to the bishops at the Restoration, was deemed uninhabitable, and used as a source of building material.

At least part of the palace was incorporated into a farm. The site was sold by the Ecclesiastical Commissioners in 1889, and placed in the guardianship of the state in 1952.

The remaining wing of Wolvesey was put to a variety of uses during the nineteenth century, including a diocesan training college, until 1926 when Bishop Theodore Woods proposed that it should once again become the bishop's house. The following year the diocese of Winchester was split into three, and Farnham Castle became the residence of the bishop of Guildford, whose diocese was created from the northern part of the former diocese of Winchester. The keep was placed in the guardianship of the state in 1933 and the eastern part of the castle used as the residence of the bishop of Guildford.

In 1955 the bishops of Guildford moved out of the castle and the former bishop's palace was used for offices and as a residential convention centre.

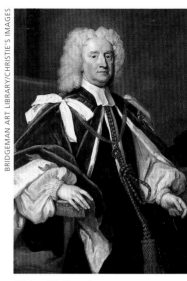

BRIDGEMAN ART LIBRARY/CHRISTIE'S IMAGES

Bishop Sir Jonathan Trelawny, portrait by Sir Godfrey Kneller

An engraving of the south front of the Baroque Palace, demolished in 1785

WOLVESEY

(Old Bishop's Palace)

TOUR AND DESCRIPTION

The remains in the care of English Heritage are sometimes called Wolvesey Castle, even though Wolvesey was built as a palace rather than as a castle. The present house called Wolvesey is the home of the bishop of Winchester and is private property.

INTRODUCTION

The site of the bishop's residence in his cathedral city was established in Anglo-Saxon times, during the tenth century, in the south-eastern corner of the city bounded by the old Roman city wall on its southern and eastern

Looking across the courtyard towards the east hall

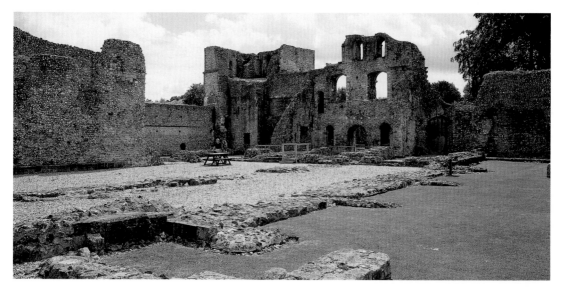

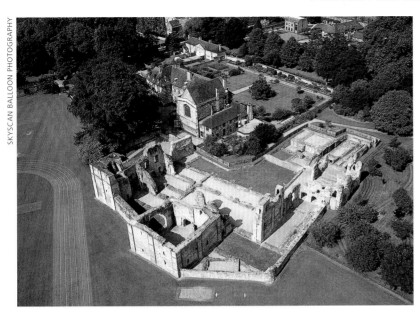

Aerial view of the palace

side, by St Mary's monastery (or Nunnaminster) on the northern side and by the cathedral itself on the eastern side.

After the Norman Conquest in 1066, the buildings of the Saxon palace were added to when the second Norman bishop, William Giffard, built the stone building known as the west hall, in about 1110. The form of the buildings as they survive today, however, is largely the creation of Henry of Blois (bishop 1129-71). The brother of King Stephen, and possessed of exceptional wealth and power, Henry built a set of buildings to create a great residence worthy of his position as the most influential churchman in the country.

The first of these buildings was the majestic east hall, built opposite Giffard's west hall, and a chapel. These were later linked by a perimeter wall, and the eastern side of the palace added to by a keep-like kitchen and the remodelling of what became known as Wymond's Tower to create a more defensive appearance during the civil wars of Stephen's reign. After Henry's return from exile the northern side was completed with a new gatehouse.

Subsequent bishops added to, remodelled and updated Bishop Henry's palace over the centuries, but there was no major change to the form of the buildings as built by Henry.

William of Wykeham carried out a major programme of repair and

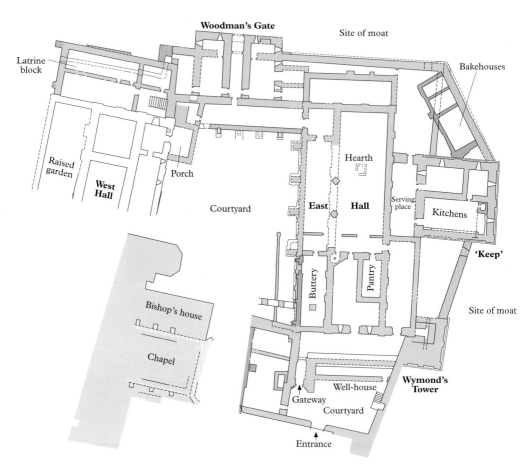

Woodman's Gate

Site of moat

Latrine block

Bakehouses

Raised garden

West Hall

Porch

Hearth

Courtyard

East **Hall**

Serving place

Kitchens

'Keep'

Bishop's house

Buttery

Pantry

Site of moat

Chapel

Well-house

Wymond's Tower

Gateway

Courtyard

Entrance

Early 12th century

Mid 12th century

Late 13th century

Late 14th century

Early 15th century

Late 15th and early 16th century

Undated, late

0 25 *Metres*

0 80 *Feet*

N

❖ THE WINCHESTER PIPE ROLLS ❖

We know much of the history of the later building work on the palaces from the annual accounts of the bishop's manors, known as the Winchester Pipe Rolls. These form a remarkably complete sequence, starting in 1208–09 and ending in 1710–11. Some years are missing, and some are incomplete as some payments seem to have been made from private accounts, but the depth of information that does exist provides an invaluable source for historians, particularly for those researching social and economic topics. Among the payments listed, the accounts include details not only of payments made for building work and material, but where stone, wood and other material were bought or transported from, and how much the craftsmen were paid and for how long.

renewal during his long tenure as bishop, including dredging the moat, building a new curtain wall on the eastern side with a new wine cellar next to the kitchen, and major changes to the private apartments in the west tower and the gatehouse.

Cardinal Beaufort carried out further work in the early fifteenth century, including the courtyard cloister walk, reroofing the east hall and rebuilding the chapel.

Although the buildings were regularly maintained, Wolvesey was used more and more for occasional visits and ceremonial purposes, including visits by royalty, rather than as a principal residence, as bishops preferred to spend their time at their other houses. The last great state occasion held at the palace was the wedding banquet of Mary Tudor and Philip II of Spain after their marriage in the cathedral on 25 July 1554.

JOHN CROOK

The ruins of the medieval palace, 1783

WINCHESTER EXCAVATIONS COMMITTEE

Fragment of twelfth-century sculpture, recovered during excavation. Traces of paint reveal that it was once brightly coloured

*Fragment of a highly
decorated door jamb that
came from Henry's palace*

TOUR

The original approach to the palace
was through a gate in the city wall,
roughly where you entered the site
from College Street. Behind you,
between here and the palace itself was
an outer courtyard, containing
buildings such as stables, barns and
the bishop's prison. Also here was the
bishop's wool house, where the col-
lection and administration of the

lucrative trade in wool from the
bishop's estates was managed. Much
of the medieval bishops' wealth
derived from the wool trade: in the
late fourteenth century the bishops
had flocks of 33,000 sheep on their
lands in Hampshire and Wiltshire.

The palace itself was arranged
around an inner courtyard, and sur-
rounded on three sides by a broad
moat. The southwestern part of the
palace, connected to the chapel, lies

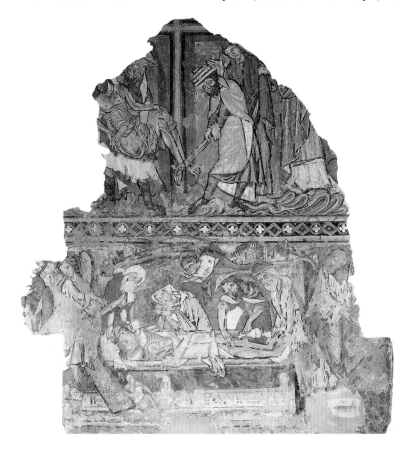

*Twelfth-century wall-
paintings from the Chapel of
the Holy Sepulchre in the
cathedral, reminding us that
the interior of Henry's
palace would have been
brightly painted and
decorated*

under the present bishop's house and garden.

From the custodian's hut, read the introductory panels and then follow the path through the doorway into the east hall.

EAST HALL

Bishops' houses followed the plans of houses of secular lords and comprised a hall and a chamber block, with the bishop's private chapel attached. Bishops' houses in the twelfth century often had two hall ranges, one for the bishop and his household, and one for public and ceremonial use.

Henry of Blois built the impressive east hall as his public hall where he would have been able to dine or receive visitors in state. Showing your face in public in your hall, and offering hospitality to household and guests, was a key function of a medieval lord. The grander the setting, and the more involved the ritual, the higher your rank and position.

What you see today is the shell of a building that underwent many alterations and refurbishments during the medieval period. The north and southern gable ends of the range survive to a reasonable height, but the rest of the hall comprises low walls and foundations. It is built of flint and mortar, with the details in stonework (or 'ashlar'). The walls were probably

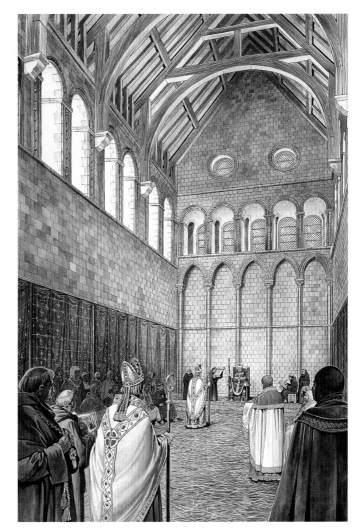

then rendered and whitewashed.

The distinctive red tiles inserted in the arches of windows and doorways, and at the corners of walls, which are most visible here, are not original but the result of consolidation work on

Reconstruction drawing by Richard Corke of the interior of Bishop Henry's east hall as it may have appeared in about 1140, soon after its completion

the ruins undertaken by the architect W D Caröe on behalf of the Ecclesiastical Commissioners in the 1920s.

Henry's original hall was long and tall, rising to the full height of the building. At the northern end you can see the remains of a high gallery built into the thickness of the wall that ran in front of rows of windows which would have flooded the hall with light from above.

A low lean-to gallery ran along the western side of the building, with a porch into the hall at its northern end. At the southern end is the gable end of the chamber block. The two doorways led into the passages to the hall. This was the main entrance into the hall from the outside, through a small gatehouse that gave access from the outer courtyard. On the ground floor the two rooms either side of the central passage were used as the pantry and buttery, where food supplies and beer and wine could be stored. On the first floor was the bishop's great chamber where the bishop could conduct more private business away from the formal setting of the hall.

In the early or mid thirteenth century the hall was remodelled and arches were inserted in the hall's western wall to create an aisle and incorporate the gallery into the main hall. The hall was subsequently reroofed by Cardinal Beaufort in 1441–42 at a cost of nearly £300, and new larger windows inserted.

WYMOND'S TOWER

Looking back at the south wall of the east hall block, to the left is a tower with a virtually solid interior.

'Wymond's Tower' is a later name given to what Henry of Blois had originally built as a 'latrine' tower at the corner of the chamber block of the east hall range. It was soon remodelled, however, and encased in stone to create a powerful strongpoint. You can see where some of this later casing has fallen away to expose the earlier smaller tower. The interior of the tower is solid, apart from the latrine shafts, up to the second floor, where small chambers gave access to loops in the wall, and a stair up to the battlements above. From these projected wooden fighting platforms that allowed defenders to hurl down missiles on any attackers below.

THE 'KEEP'

From the centre of the hall, turn right and enter the square-shaped building next to it.

This building has provoked much comment and speculation over its function. Although from the outside it looks very much like a square keep, the relatively thin walls and the fact that it appears never to have had an upper floor have suggested that it was no more than the kitchen block.

Further confusion has been caused by a reference to a 'very strong tower' from which the bishop's forces propelled firebrands to burn the city during fighting with supporters of the Empress Matilda in 1141.

The exterior of the building certainly gives the impression of a defensive structure, jutting out into the moat, and was probably designed to deceive, with arrow loops at several levels, buttresses and a 'chamfered' or splayed base.

Inside the space was divided by partition walls, with the rooms open to the rafters. The spaces are for the massive fireplaces in which the food for the meals in the east hall would have been cooked.

Food, and the ritual involved in serving and eating it, was a major part of the routine of the medieval household, taking up a large portion of the day. The kitchens of great households, like that of the bishops of Winchester, were therefore huge, well-suited to preparing the large meals that were required to feed the bishop's household and guests, and high-ceilinged to help evacuate the

Reconstruction drawing by Richard Corke of the interior of the kitchen

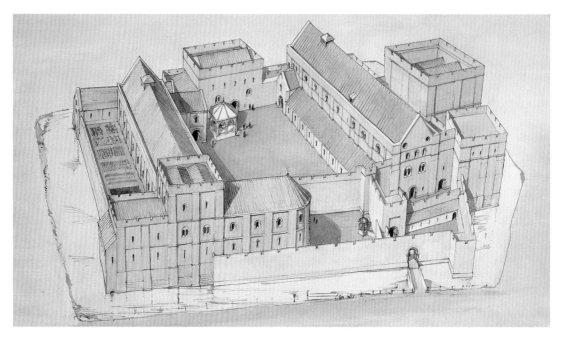

Reconstruction drawing of Wolvesey by Terry Ball as it may have appeared in 1171, at Henry of Blois' death, showing the east hall and 'keep' on the right, and west hall on the left

heat and smell.

To the left of the hall is an area laid with grass. This represents the central courtyard. To the north, a later medieval passageway, now laid with gravel, linked the east and west halls and created a cloister walk.

WOODMAN'S GATE

From the central courtyard, walk across to the ruins of the gatehouse to the north of the later passageway.

This gatehouse was built by Henry of Blois in the later part of the twelfth century after his return from exile in 1158. It is military in style and function: a drawbridge crossed the moat, raised by a counterweight that was housed in a stone-lined pit. A central passageway is flanked by two rooms on each side, each only accessible from the passageway. The outer rooms had arrow loops for archers to cover the curtain wall and gatehouse approaches.

In the late fourteenth century, William of Wykeham seems to have moved his exchequer to the gatehouse and the building was subsequently remodelled to form accommodation for the bishop's treasurer. Internal walls were removed, windows enlarged and fireplaces inserted at first-floor level.

WEST HALL

To the left of Woodman's Gate is the west hall, on the opposite side to the east hall. Walk over to the wooden steps that give you a view over the surviving walls.

Most of the west hall block now lies under the garden of the present bishop's house. However, excavations during the 1970s revealed much of its plan, and the northern end is uncovered for view. The building was built by Bishop William Giffard in about 1110, possibly as an addition to the existing Anglo-Saxon bishop's residence which the first Norman bishops occupied after the Conquest.

The lower level, apart from the eastern side, was filled with chalk to first-floor level to raise the building higher and present a more impressive front. Giffard's 'hall' in fact comprised a series of rooms for the bishop's private accommodation and business functions, plus some accommodation for his household, rather than a hall in the true sense of the word.

At the southern end was a tower, at least three storeys high, that originally contained the bishop's 'exchequer' or treasury, private chapel and a private room or bedroom at the top. In the 1370s the tower was thoroughly remodelled by William of Wykeham in order to provide more up-to-date private accommodation and the treasury moved, perhaps to Woodman's Gate.

At the northern end is another block added by Henry of Blois as part of the wall linking the west and east hall, and originally designed as a latrine block – note the drain emptying through the arches in the west and north walls into what was the moat.

CHAPEL

Attached to the west hall was the bishop's chapel. Today this is part of the present bishop's palace and is not open to the public. However, it is important in visualing what the medieval palace may have looked like, as it lies at the same first-floor level as the west hall rooms. The present chapel was probably built by Cardinal Beaufort during the mid-fifteenth century, and restored by Bishops Duppa and Morley in the 1660s, but is built on the foundations of Henry of Blois' Norman chapel.

View of Woodman's Gate from the central courtyard

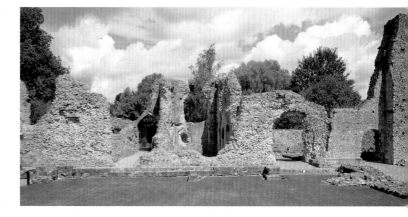

❖ BISHOPS AND KINGS ❖

Medieval bishops were not only important men in the hierarchy of the Church, but often played influential roles as advisers to the monarch. Bishops depended on the king for their appointment and the king could enjoy the revenues of the bishopric between appointments. Earlier bishops were often monks or scholars, but many royal career officials were also appointed as bishops during the Middle Ages.

Royalty were therefore frequent visitors to the palaces: for example Henry III visited Winchester and Waltham many times; in 1306 Wolvesey was prepared for the queen to bear Edward I's third child; Edward III and Queen Philippa were there in 1330 for the parliament held at Winchester. Tudor monarchs were also frequent guests. The palaces were conveniently situated on the roads between London and the ports of Southampton and Portsmouth, and were suitable places for the monarch and their household to lodge while travelling. The size of the palaces

meant that they could accommodate the large numbers of guests and provide aristocratic entertainment, such as hunting in the bishops' deer parks.

The bishops were expected to entertain their royal guests in style. Two feasts for Richard II in September 1393 for 210 and 367 guests respectively cost £10 1s 2d and £39 15s 3d, compared to £3 or £4 for a normal day's expenses. The bishops also held their own feasts: Henry Beaufort held a magnificent one at Winchester Palace in 1424 for the wedding of his niece Joan to King James I of Scotland. There were state occasions too: the wedding of Henry IV and Joan of Navarre was held in Winchester Cathedral in February 1403 and a great feast held at Wolvesey before the wedding at a cost of £522 12s, including cygnets, capson, venison, griskins, rabbits, pullets, partridges, woodcock, plover, quail, snipe, roast kid, custards, fritters, cream of almonds, pears in syrup and 'subtleties with crowns and eagles'. A century

FOTOMAS INDEX

A 'kissing shilling': coin from 1554 with the portraits of Philip and Mary as joint monarchs

and a half later, Queen Mary stayed at Wolvesey for her marriage to Philip of Spain on 25 July 1554, and the wedding breakfast was held in the east hall.

The palaces were also used for diplomacy. Henry V met the French ambassadors at Wolvesey in 1415 who tried to dissuade him from pursuing his claims to the throne of France (immortalised in Shakespeare's *Henry V* with a present of tennis balls). In 1522, Henry VIII entertained the Emperor Charles V in style at Bishop's Waltham Palace, where a treaty was signed formalising an alliance against Francis I of France.

BISHOP'S WALTHAM PALACE
TOUR AND DESCRIPTION

The manor of Waltham had formed part of the estates of the bishops of Winchester since the early tenth century, and the Anglo-Saxon bishops may have had a residence there. The first reference to a castle or palace here is in the Winchester Annals for 1138 when it is included in the list of castles built by Bishop Henry of Blois. Remains of some of these earlier buildings have been revealed by excavation. After his return from exile in 1158, during which some of his castles were destroyed, Henry seems to have rebuilt Waltham on a grander scale, the buildings forming the basic shape that the palace retains to this day.

The palace was regularly used by the bishops during the thirteenth and fourteenth centuries, and the accounts from the Winchester Pipe Rolls reveal continuous spending on maintenance and rebuilding, including a kitchen and brewhouse in 1252 and a new lord's chamber in 1340.

However, it was William of Wykeham, who became bishop in 1367, who was responsible for the major transformation of the palace, the remains of which can be seen today. Wykeham spent over £1,500 remodelling the principal buildings to create a more up-to-date residence. The hall was rebuilt first, in 1378–81, followed by a new service area and kitchen between 1387 and 1393. Finally, a new great chamber was built in 1394–96.

Cardinal Beaufort added an extra storey to the west tower in 1406 and built the new chapel in 1416. Between 1438 and 1443 the new lodging range and gatehouse were added. Bishop Langton refaced Beaufort's lodging range in brick at the end of the fifteenth century and rebuilt the inner gatehouse. He may have also been responsible for the brick wall and corner turrets enclosing the garden.

The coat of arms of Bishop Langton and those of the bishopric of Winchester, found among the rubble of the inner gatehouse

Drawing of a statue of Cardinal Beaufort, from Langton's gatehouse

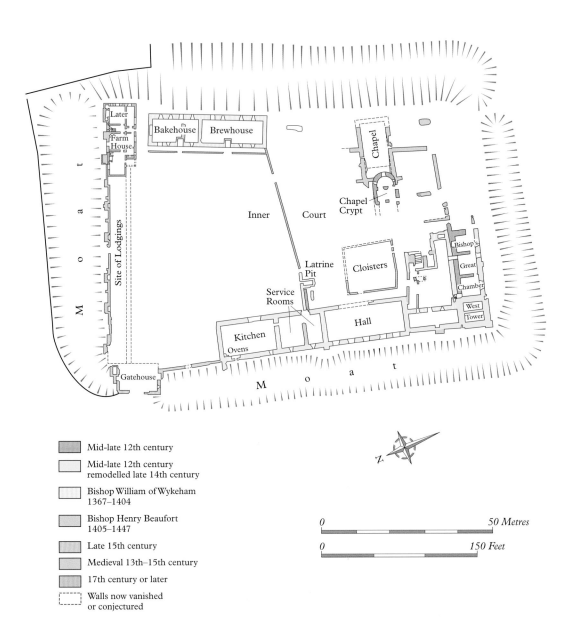

Later
Farm
House

Bakehouse Brewhouse

Chapel

Chapel
Crypt

Inner Court

M o a t

Site of Lodgings

Latrine
Pit

Cloisters

Bishop's

Great

Chamber

Service
Rooms

West
Tower

Hall

Kitchen

Ovens

Gatehouse

M o a t

Mid-late 12th century

Mid-late 12th century
remodelled late 14th century

Bishop William of Wykeham
1367–1404

Bishop Henry Beaufort
1405–1447

Late 15th century

Medieval 13th–15th century

17th century or later

Walls now vanished
or conjectured

0 50 Metres

0 150 Feet

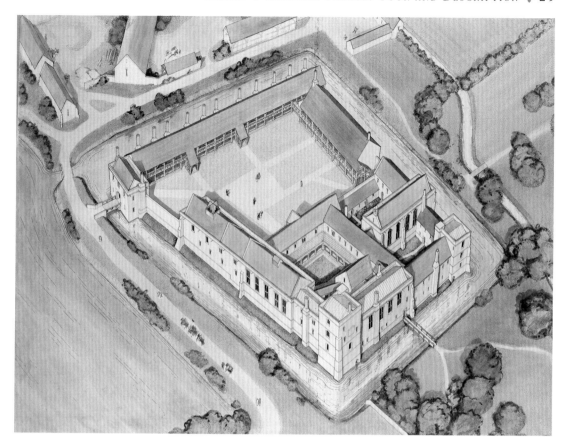

During the Civil War, the palace was fortified in support of the king, but after the royalist defeat at Cheriton in 1644, it was captured by Parliamentarian troops and parts of the complex set alight. When the property was restored to the bishops after the Restoration it was deemed uninhabitable and used as a source of building material.

What can be seen at Bishop's Waltham today are the ruins of the inner courtyard of what was once a large group of buildings that comprised not only a home for the bishop, but accommodation for his household and the buildings necessary for its role as the centre of an agricultural estate. When the bishop was in residence the site would have been crowded and busy with guests and officials. At other times life would have revolved around the cycles of the farming year.

Reconstruction drawing by Richard Warmington of Bishop's Waltham Palace as it may have appeared in about 1450. The west tower is at the bottom foreground

The kitchen on the ground floor of the farmhouse

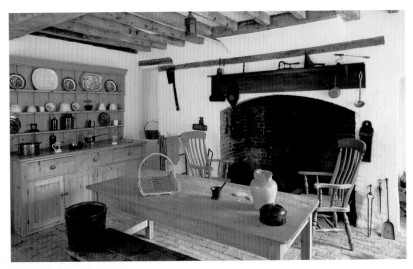

LODGINGS AND FARMHOUSE

The ticket office and shop is on the ground floor of part of Cardinal Beaufort's lodging range. After the destruction and abandonment of the palace, this part of the building was incorporated into a farmhouse and the alterations have obscured its original appearance.

The ground floor represents the building as it appeared during its use as a farmhouse, with a farmhouse kitchen recreated in the room at the far end.

On the upper floor, later alterations have been removed, so you can see the layout of the lodgings more clearly. There was originally no internal staircase between the floors, ground-floor and first-floor rooms being self-contained, with an open wooden gallery running outside at first-floor level. The lodging range provided 22 self-contained rooms, in a half-timbered building with brick chimney stacks decorated in a black and red 'diaper' pattern. The building was later faced in brick by Bishop Langton. Each upper room had a door and window to the gallery and a window in the opposite wall. Each would have had a fireplace – the one you can see is original but has been moved from its position. The upper rooms were open to the rafters.

Cross over to the west range of buildings

WEST RANGE

The west range was the heart of the palace and contained the bishop's great hall, serviced at one end by the

❖ LODGINGS ❖

Lodgings were individual 'bed-sitting rooms' often constructed in late medieval castles and large houses to accommodate the growing numbers of followers who belonged to the households of great lords in the late medieval period. In earlier times, these followers would have slept communally in one room – for instance, a separate 'knights' chamber' or 'esquires' chamber' existed in the inner core of the palace. By the late fourteenth and early fifteenth century, however, greater privacy was expected for the persons of senior rank who accompanied great lords.

At Bishop's Waltham the

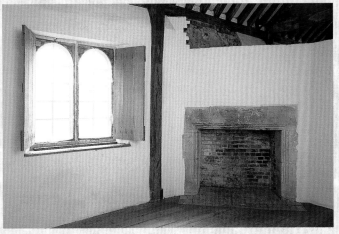

Interior of one of the first-floor rooms in Beaufort's lodgings

lodgings would have accommodated the bishop's officials or the more important of the bishop's guests. For a person of a gentry family or with education to serve a great lord in this way was no shame – on the contrary it reflected the power of the lord and brought honour on the servant.

kitchen and service rooms, with access at the other end to the bishop's private accommodation in the west tower, adjoined by the great chamber. The buildings you see today are twelfth-century in the lower parts of their walls, but the upper parts were rebuilt in 1387–93 as part of Wykeham's remodelling of the palace when the earlier walls were taken down, rebuilt and heightened.

The bare flint walls we see today

give little impression of how these rooms would have originally appeared. The exterior walls were plastered, the details carved in high-quality stonework; windows were glazed, often with painted glass, and with shutters; the floors laid with coloured tiles, and the rooms spanned by fine beamed wooden roofs covered in lead or tiles. The accounts and other documents sometimes give a glimpse of these interiors: in 1443

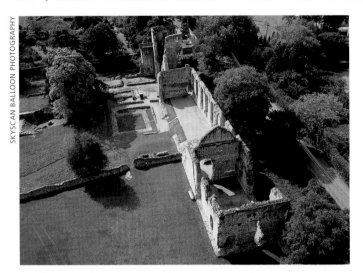

Aerial view of the west range of the palace

The great hall

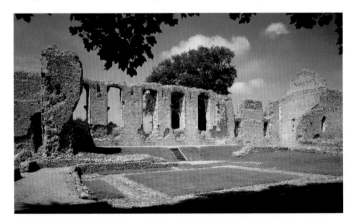

Beaufort paid £18 for 5,000 imported Flemish tiles for the hall and cloisters, and in 1438 the rooms in the west tower were panelled in wood. The walls of the principal rooms were painted or hung with tapestries or hangings. In his will Beaufort bequeathed his 'blue bed of gold and damask' from the room she had stayed in at Waltham to Queen Margaret, wife of Henry VI, together with three sets of tapestries from the same room.

KITCHEN

Wykeham's kitchen was two storeys high, and probably had a high roof to extract the smoke and cooking smells. Some remains of the large fireplaces and ovens survive in the west wall. A well provided fresh water.

From the kitchen, food would have been taken up a flight of steps into the servery before being taken into the hall. Here also were the buttery and pantry where wine, beer and bread were stored. Above these rooms was a large room, with windows and a fireplace.

HALL

The original twelfth-century hall was rebuilt by Wykeham, who raised the floor level to create an impressive suite of state rooms at first-floor level. Five of the grand windows on the outer wall of the hall have survived, giving some idea of the impressive nature of the building.

Here the bishop could dine in state and impress his guests. The bishop would have sat on a raised platform or dais at the far end of the hall while the food was brought in formal procession from the doorway at the other end. Behind the wall was a passage

(now blocked off) to his private accommodation in the west tower.

WEST TOWER

As with the tower at Wolvesey (see page 25), the west tower provided both private accommodation for the bishop and acted as a strongpoint in the palace. The tower was built by Henry of Blois and altered by Wykeham. A fourth storey was added by Beaufort in the fifteenth century. The ground floor was a basement, entered only from the floor above. The first floor contained two windows and had access through a passage to the bishop's hall. The second-floor room was probably Wykeham's 'high chamber' or bedroom, with its own private latrine in the thickness of the wall. The top floor added by Beaufort had its own fireplace and five windows.

GREAT CHAMBER

To the east of the west tower on first-floor level was the bishop's great chamber, or audience chamber, where he would have conducted business and received visitors. Again, the form of the building dates from the twelfth century, but Wykeham enlarged the room by widening it on the courtyard side, adding new large windows, a fireplace and a new shallow pitched roof. You can see some of the earlier twelfth-century

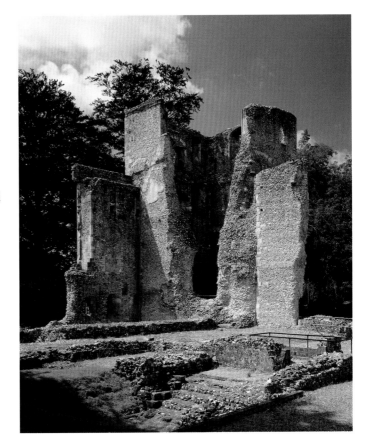

round-headed windows blocked up. The ground floor of the great chamber consisted of small basements or 'undercrofts'.

The west tower, with the great chamber in the foreground

CHAPEL

From the great chamber walk over to the depression in the ground shaded by a large tree.

Like the two-storey chapel built by

The chapel crypt

Henry of Blois at Wolvesey, the twelfth-century chapel at Waltham consisted of a underground or semi-sunken crypt with a chapel above, both ending in a semi-circular apse. The crypt can be seen today, built of high-quality carved stone (or 'ashlar'), and with two of the central columns that supported the stone vault surviving. In 1416–17, Beaufort started work on a new chapel, whose rectangular foundations can be seen to the north of the crypt.

INNER COURTYARD

Much of the area now grassed over would have been filled with buildings. Fragmentary remains survive of this complex of buildings, many of which were built around a small central cloister, part of whose passageway survives. The rooms in this area comprised the communal rooms like the knights' and esquires' chambers, later split up into lodgings for guests and officials.

The wall that divides the site dates from when the site was used as a farmyard, but may represent the line of an earlier division within the inner courtyard.

BAKEHOUSE AND BREWHOUSE

Cross over to the ruined building next to the ticket office and shop.

This building was the bakehouse and brewhouse, built by Wykeham in 1378–81. Providing bread and ale was a major preoccupation for the later medieval household. Ale was the

The interior of the bakehouse and brewhouse

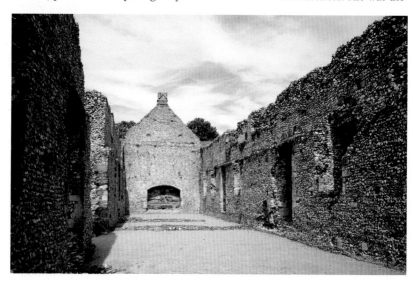

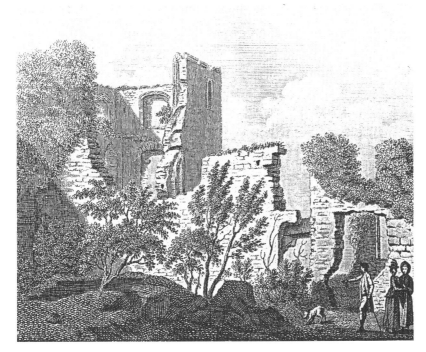

Engraving of the ruins of the west tower, 1784

main drink, and vast quantities were brewed and consumed daily. In 1439–41, Beaufort added an upper floor and linked it with a wooden gallery to his newly built lodging range. A small oven survives in middle, and at the north end there is a large oven.

OUTSIDE THE PALACE

The inner courtyard of the palace was surrounded by a moat, parts of which survive. To the north, where the modern road is now, was the outer courtyard which contained barns and stables and a gatehouse into the town. Here the agricultural activities of the surrounding estate would have been conducted. To the west were the fishponds which supplied fresh fish for the bishop's table. Fish was a delicacy to be enjoyed by the upper classes, and fishponds required careful tending and cultivation.

To the south was the park where the bishops could enjoy hunting over their extensive lands. Part of this park was enclosed by a brick wall with elaborate corner turrets, which can be seen today, probably by Bishop Langton in the late fifteenth century to form a garden.

FARNHAM CASTLE KEEP TOUR AND DESCRIPTION

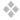

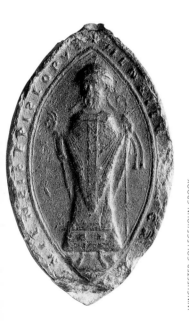

The seal of Henry of Blois

Farnham Castle stands on the crest of a hill overlooking the town to the south, but with level ground to the north. Farnham itself was a convenient stopping place between London and Winchester, as well as the centre of the bishop's eastern estates. It therefore soon developed as a favourite residence of the bishops, but also represented a key strategic asset, dominating a major road between London and the south coast ports.

Farnham had formed part of the estates of the bishops of Winchester since the seventh century, but the castle was the creation of Henry of Blois in the first half of the twelfth century. Henry's original castle seems to have been pulled down by royal order after 1155, but the castle's defences were rebuilt in stone in their present form in the late twelfth and early thirteenth centuries, with the earlier earthen mound, or 'motte', encased in stone to form a shell keep, and an outer curtain wall built. The castle became a regular residence for the bishops, and was frequently visited by royalty.

Farnham Castle exchanged hands several times during the Civil War, and in 1648 it was sold. Part of the wall of the keep and possibly the outer curtain wall was blown up with gunpowder to render it unusable. In 1660 the castle was restored to the bishops and Bishop George Morley started an extensive programme of repairs, mainly devoted to refitting the interior of the medieval hall, chapel and apartments. Morley died at Farnham in 1684, and the castle became a favourite residence for succeeding bishops who made further

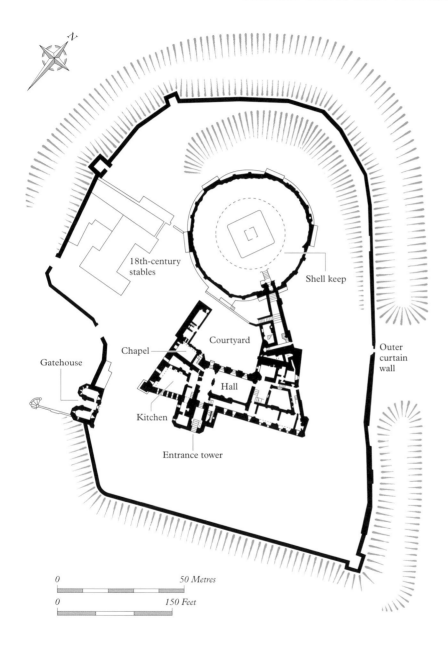

N

18th-century stables

Shell keep

Courtyard

Chapel

Outer curtain wall

Gatehouse

Hall

Kitchen

Entrance tower

0 50 Metres

0 150 Feet

additions and alterations. In 1927 part of the castle became the residence of the bishops of Guildford, formed from the division of the diocese of Winchester into three, and in 1933 the keep was placed in the guardianship of the state.

TOUR

The keep is in the care of English Heritage. The other parts of the castle are in private hands but part of the interior is open to the public at certain times. Please enquire at the custodian's office.

THE KEEP

The keep at Farnham as it appears today is unusual because the large earthen mound, or 'motte', similar to that found at many early Norman castles, was later encased by stone to create a 'shell keep' when the motte was reused at a later period.

The keep was the defence of last resort, where the defenders could have retreated to if under sustained attack. In the later medieval period, the interior of the shell keep was lined with half-timbered buildings that could be used as extra accommodation, although the main life of the castle took place in the courtyard below, centred around the hall. Here also were the kitchen, chapel and bishop's apartments that can be seen at the other palaces.

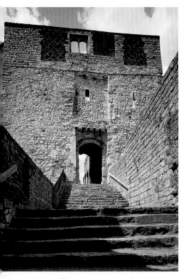

The entrance to the keep

ENTRANCE TO THE KEEP

Three flights of stairs lead up to the keep doorway, with a deep drawbridge pit, now filled in, on the landing before the final flight of stairs. The first flight of steps the visitor ascends is modern – the historical route can be seen running down to the courtyard at right-angles to the modern steps.

Two walls once projected either side of the doorway to support a superstructure that operated the drawbridge. The blocked doorway that gave access to this can be seen above the main door. Inside the doorway you can see the position for a portcullis and, above you, a 'murder hole' through which missiles could be dropped on any attackers below.

The two brick walls on either side of the passageway are Tudor replacements of wooden linings that acted as revetments to support the earthen banks on which wooden buildings were built on either side of the entrance gate. In the fourteenth century these buildings included a small chapel and a small hall, forming a self-contained suite of accommodation, perhaps within the gatetower. During the later medieval period the interior of the keep was lined with half-timbered buildings and lean-to storage areas, of which only the stone foundations survive today, and the buildings in the keep were probably used as accommodation by the small

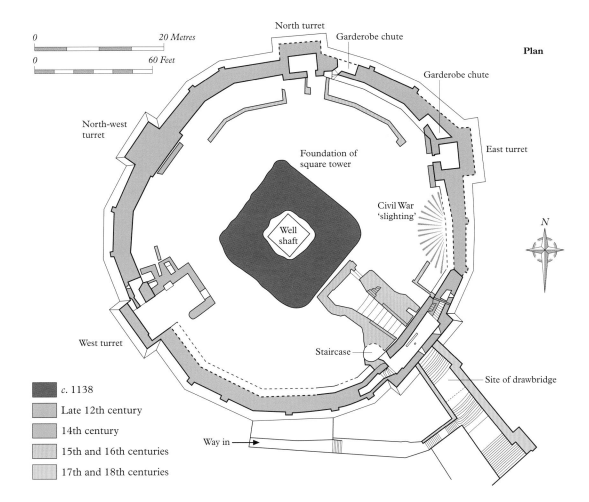

group of retainers permanently based at the castle.

INSIDE THE KEEP

Inside the shell wall were four small turrets, each accessed from the interior courtyard of the keep, apart from the north-west turret, which was solid at ground-floor level. The west turret was later altered to create a room with a fireplace. A wall-walk ran along the top of the wall with doors into the turrets at first-floor level. Latrine chutes can be seen on the north-east wall, originally discharging

The interior of the keep from the entrance tower

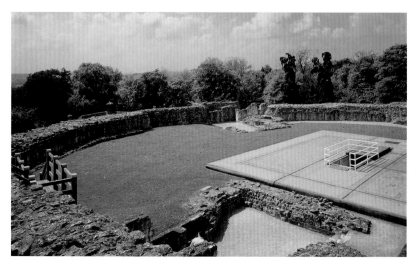

straight into pits at the bottom of the wall.

A staircase leads up to the rooms above the entry tower. Today the site of the portcullis is shown by a line of stones in the floor, and the murder hole is covered by glass. The room above had two fireplaces, one of which had the initials RW (for *Ricardus Winton* – Richard Fox, bishop 1501–28), who made major alterations to the castle in the 1520s. On either side steps lead up to surviving portions of the wall-walk from where there are good views over the rest of the castle and the town.

Central tower

In the centre of the keep courtyard is a large concrete slab. This now protects the remains of the foundations of a tower and well shaft that were excavated in the late 1950s. An observation gallery has been slung from the slab so you can walk down and inspect the well shaft.

Most early Norman castles had a flat-topped earthen mound, or 'motte', at their centre, usually surmounted by a wooden tower and ringed by a wooden fence. In the case of Farnham, it appears that the mound was created at the same time as the tower foundations, and the tower built on these foundations may have been built of wood or of stone. Why it was built in this manner is unclear: it may have been to give the base of the tower added protection, or it may have been simply for display, creating a high and impressive tower that would have dominated the hill and town.

The tower may have been demolished after 1155 – an entry in the

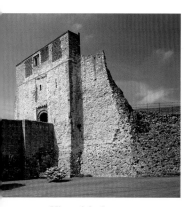

View of the keep

royal accounts refers to a payment to the sheriff of Hampshire to destroy it. Certainly by the thirteenth century the area on top of the mound had been levelled.

OTHER PARTS OF THE CASTLE

The keep and inner buildings of the castle were enclosed by an outer stone curtain wall, along which there were several projecting towers, and a deep ditch. A twin-towered gatehouse, today rendered and with Victorian additions, was the main entrance to the castle, with a drawbridge spanning the ditch in front. To the north of the castle were the large fenced deer parks that provided the bishops and their royal and distin-guished guests with the hunting for which Farnham was famous. Near the castle, and possibly within it, were the barns and other buildings associated

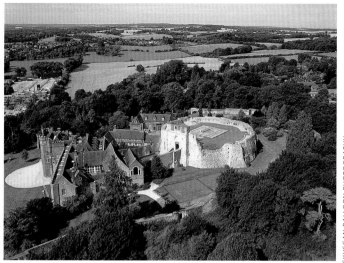

Aerial view of the castle from the east

SKYSCAN BALLOON PHOTOGRAPHY

Section

c. 1138	
Late 12th century	
14th century	
15th and 16th centuries	
17th and 18th centuries	

0 — 20 Metres
0 — 60 Feet

Shell wall
Late medieval surface
Square tower
Entry passage
13th-century filling
Mound 12th-century
Mound 12th-century
Site of drawbridge
Original ground surface
Well

Gatehouse to the keep in the nineteenth century

with the agricultural activities of the estate.

The main residential buildings of the palace are grouped in the courtyard, and comprised a hall, kitchen, chapel and entrance tower, as well as the bishop's private apartments. The impressive entrance tower, constructed of brick in a 'diaper' pattern, dates to 1470–75 and was built by William Waynflete.

The tower provided not only a display of the bishop's wealth, but could also be used as a strongpoint in case of attack. In this it relates to the earlier great brick tower built by Waynflete's Lincolnshire contemporary Lord Cromwell at Tattershall Castle, or the contemporary brick tower built by Bishop Rotherham of Lincoln at his palace at Buckden in 1480–85.

The hall has been much-altered, particularly by Morley, but some elements of the medieval structure survive. The blocked-in arches of the aisles of the chapel can be seen from the courtyard where the slope of the ground means that the first-floor chapel appears at courtyard level.

❖ TRAVELLING ❖

Medieval bishops spent much of their time on the move travelling around their diocese, staying at their manors and attending the royal court or visiting London. Most of the houses would therefore have been empty for much of the year, with a small resident staff in charge of the house and the administration of the surrounding manor estates. Only when the bishop was expected to arrive would the numbers of people swell and activity increase. We know from the accounts in the Pipe Rolls of the extensive preparations that had to be made to plan for the arrival of the bishop's household: huge stocks of food and fuel had to be gathered and supplied from the various estates; repairs to the accommodation had to be carried out; and entertainment planned.

The bishop himself and his senior officials would have ridden on horseback, followed by a large household of perhaps 50 to 100 officials and servants. His belongings followed in wagons. These contained chests, moveable furniture, wall-hangings, linen, utensils and other equipment that were regularly transported between the houses.

WINCHESTER PALACE, LONDON

The need for medieval bishops to attend the monarch, or conduct business, meant that most sees had their own houses in London where the bishop and his officials and servants could stay. Some of these evolved into sizeable palaces. The London house of the bishops of Winchester was on the south bank of the Thames in Southwark. Today all that remains above ground is the west end of the hall, with its elegant rose window, which is in the care of English Heritage.

The first buildings were constructed by Henry of Blois, who bought the site, but were extensively remodelled in the thirteenth century, especially by Bishop Peter des Roches who rebuilt the hall in 1220–21. In 1356–57, Bishop William Edlington built a new suite of private accommodation next to the chapel to replace the by-then old-fashioned great chamber. Other bishops made alterations and repairs to the fabric. The last bishop to use the palace on a regular basis was Lancelot Andrewes, who died there in

Detail from Wencelaus Hollar's 'Long View' of London, 1647, showing the buildings and gardens of Winchester Palace in the foreground

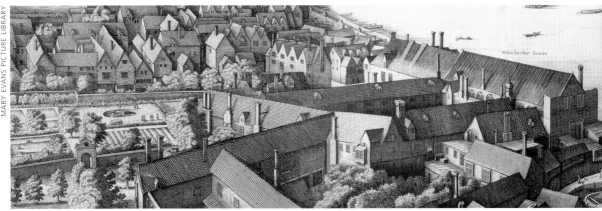

winchester house

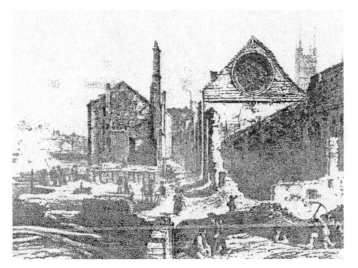

Engraving of the ruins of the hall after the devastating fire of 1814

The west wall of the hall of Winchester Palace

central courtyard. An outer courtyard contained stables and the bishops' prison, while to the west lay a garden. The prison seems to have had three sections, for women, men and clerks (those under holy orders), and by the fifteenth and sixteenth century had become notorious, so much so that its name 'clink' had become a slang term for jail and is remembered today in nearby Clink Street. There was also a permanent ducking stool, reminding us that church courts dealt with cases of adultery and matrimonial disputes.

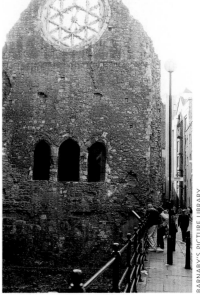

BARNABY'S PICTURE LIBRARY

1626. During the Civil War it was used as a prison for royalists, and after 1663 was divided up into tenements. It later disappeared among warehouses and other buildings. A fire in 1814 destroyed much of what had survived, before clearance of the site and excavations in the 1980s prior to redevelopment revealed some of the details of the plan.

The buildings comprised a hall parallel to the river frontage, with a kitchen at one end, and the bishop's great chamber at the other end. A chapel lay at right angles to this range, and a series of rooms for the bishop's household lined an inner